A Zombie Apocalypse

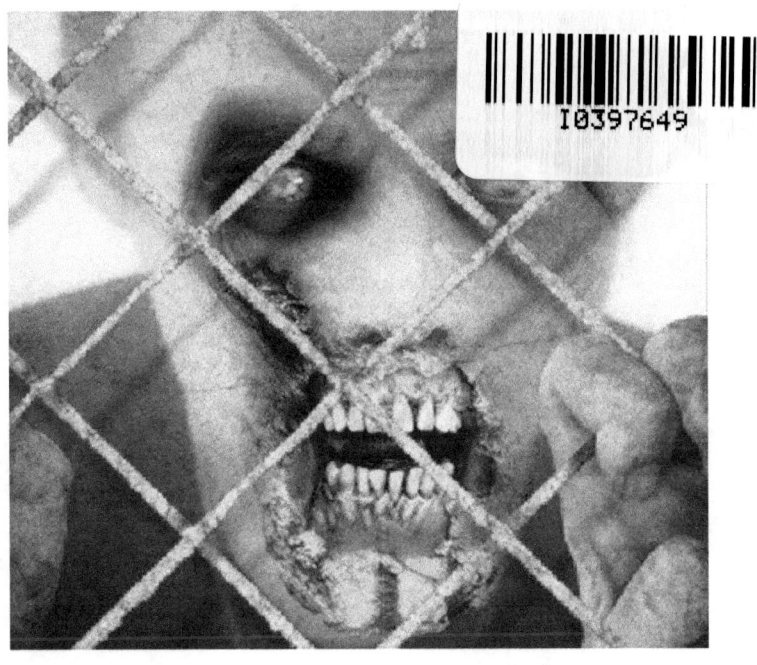

M.R.F. Plays

M.R.F. Plays

First Published 19th April 2013

First Performed at Leeds Seven Arts 14th May 2013

First Edition

This Copy

Second Edition Published 5th June 2014

Copyright © Martin Ryan Ferry

All Rights Reserved. Without limiting the rights under copyright reserved above, no part of this publication may be reproduced, stored in or introduced into a retrieval system, or transmitted, in any form, or by any means (electronic, mechanical, photocopying, recording, or otherwise) without the prior written permission of the copyright owner of this book.

ISBN: 978-1-291-54376-6

For Performance Rights Contact

Martin Ryan Ferry

MRF-Plays@live.com

Characters

James – James has recently accepted a new job at a law firm, and his hope for a fresh start in life. Alongside his life his is newly married life with Betty. He is not a man who cannot make hard decisions nor can he choose between his wife and brother.

Betty – Betty is very contriving when it comes to her big decisions within the marriage. She is can be a very patronising character when she wants to get her own way.

Ned – Ned is James's brother and always gets him into trouble. He loves his gaming and horror films with passion. Above all he enjoys winding Betty up, he sees how contrive she is of his brother and tries to open James's eyes to the truth.

Sarah – Sarah is Betty's best friend and is childhood sweetheart to George. At times she can be inpatient when George moans, and that's when she likes to show she is wearing the pants in the relationship.

George – George is a posh snob, he likes to think he knows everything and that he is better than everyone else. When it comes to real life situations he doesn't handle the pressure well as he should, and immediately thinks of the worst case scenario.

Chris – Chris is then eldest character in the play, he is wise but at times seems distant when day dreaming. Although at times he feels out of place with the other characters being so young. This is why he mostly stays quiet when disputes happen.

Authors Notes

My inspiration for this play came to me one day when I was in a garden centre with a few friends. About time we reached the garden tools section of the centre I asked my friend, what would you use in a zombie apocalypse? We went from garden folks to spades, not knowing how time has flown by. It is amazing how you can have a discussion about what you would do, or use in a zombie apocalypse, for so long.

That was one example but there have been many discussions like this in many different places. Then I thought if I and my friends can have fun talking about zombie attacks, then what if I created a play about it. There for I created A Zombie Apocalypse, a play about the beginning of the zombie apocalypse and two brothers must decide what to do to survive the horror.

So what would you do if zombies burst through your door now?...

Scene One

(A digital clock projecting the time on stage displays 8:00am. Lights fade up showing the audience the living room; Betty enters, as she sits down to read her magazine. James then enters onstage buttoning his shirt and doing his tie.)

Betty: You're not wearing that tie are you?

James: Yes, why what's wrong with it?

Betty: doesn't suit you, it's an awful colour, here put this one on.
(Pass James a tie she had in her pocket).

James: And this does?

Betty: Of course now stop being silly put it on… I need you to come straight home after work this evening. Sarah and George are coming round for tea.

James: Tonight's the night I go to Ned's.

Betty: I'm sure your brother can survive one night without you.

James: That's not the point.

Betty: What is the point James? Your brother is a bad influence on you.

James: How is he a bad influence?

(As Betty lists out the reasons why Ned is a bad influence, she counts the examples with her fingers).

Betty: He always gets you drunk!

James: I was just having fun.

Betty: He took you to a strip club!

James: It was my stag night.

Betty: And he got you arrested!

James: That wasn't his fault… ok maybe it was. Look Ned is a good guy you just need to get to know him the way I know him.

Betty: I still don't like him, he is so immature and he has no manors. I just want tonight to be just us and friends, having a meal and a few laughs. After everyone goes we can snuggle up to a movie, just like what we used to do.

James:	Ok I guess it can't harm and you don't have to like Ned, you just need to...

(As James is in mid-sentence, a fast and loud knocking starts at the front door).

Betty:	Who the hell is that?
James:	I don't know maybe we should pretend were not home and hopefully they will go away.

(Betty glares at James they both exchange a look at each other).

Ok I'll go see who it is.

(James goes to the window hoping he can see who is at the door, and then he goes to the door, as James opens the door Ned bursts into the house in a panic. Immediately Ned closes the door behind him in a great hurry and begins locking the door).

Ned what's a matter?

(Ned tries to catch his breath back while going around the room in great excitement).

Betty:	What is he doing here?
James:	I don't know, Ned what's going on?
Ned:	*(Ned still all excited)* Oh my god... its happening... their finally here.... zombies!
James:	What?
Ned:	Zombies James!
James:	What do you mean zombies?
Ned:	Zombies James as in the living dead!
Betty:	Oh god he's high again.
Ned:	I'm not high you harpy!

(Betty looks at Ned shocked by his rude behaviour).

Betty:	You good for nothing piece of...
James:	Okay! Both of you, now Ned tells us from the beginning what happened?
Betty:	I don't have time for this *(Exits the room).*

Ned: It all started this morning I was down the river with Tommy and Old Phil; you know Old Phil, talkative old guy who never catches any fish. Anyway we were sat there having a few beers, admiring the view. There are these fit girls who jog by there every morning, and I just don't mean fit I mean stunning babes' small ass...

James: Ned back to your point.

Ned: Right, anyway were drinking and admiring the view, when we heard a scream from down the pathway. So me and Tommy decide to go see what is happening. So we get the bottom of the pathway that leads to avenue, and there was blood on the floor, we thought it might have been from a fight or accident. Then all of a sudden we hear something smash, like a window. So we came further into the street, we see this woman running out of her house; she was in tears full works. So me and Tommy hid behind a car in case some meat heads come out. Then we heard this groaning sound so we look back up and this guy covered in blood, he went up behind the woman and begins biting her neck, like a zombie! After we saw that we knew we had to get out of there, so we backed up to the river and ran over the bridge and down the pathway away from there.

James: Sounds messed up to me and sounds like some guy went nuts and went on a killing spree.

Ned: It wasn't over just like that, and it wasn't some nut case, this was on a larger scale. We came down the alley near the brewery, and we saw one of girls who were jogging earlier. She was just standing there; Tommy went up to her trying to get her attention. He must have figured she had earphones in, because she didn't turn round. Then I saw blood dripping down from her hands, I quickly told him to stop and look at her hands. So he looked at her hands and slowly started to back up. She must have heard him because she slowly turned around towards us, and her mouth was covered in blood, and she made a groaning sound. Tommy immediately started coming back to me when he tripped over himself. The zombie went for him, he tried to fight her off but she got lucky and bit him.

James: Ned I'm sorry.

Ned: No don't be... he was an alright guy but he was a dickhead anyway. I always said to him, when a zombie apocalypse happens the first to go are the fat people!

James: Ned!

Ned: Arghhhhh! I can't believe this is happening!

James: It's ok Ned he was one of your best mates.

Ned: No it's not ok James, I did bloody nothing! I just froze while Tommy became a human happy meal!

(The room is filled with silence pulls himself together, then Betty enters the room).

Betty: Is he still playing up like an idiot?

James: Betty don't, He's just lost one of his friends.

(An awkward silence fills the room Betty feels a bit embarrassed by the situation).

Betty: Look Ned I'm sorry.

Ned: It's ok.

Betty: what happened to your friend?

Ned: He got eaten by a zombie.

Betty: Oh for fuck sake!

James: Betty!

Betty: Look James I can't be arsed with your brother's stupid games, I'm off shopping I want your stoned head brother gone when I get back!

James: Nooooo! Betty you can't go out there!

Betty: Why not?! Oh wait Ned's zombies are going to get me.

Ned: Maybe you should let her go.

Betty: Oh you would love that wouldn't you? You are a total waste of space Ned, you always have been and always will be.

Ned: And you will always be a bitch Betty.

Betty: You immature piece…

James: Let's all calm down.

(Betty storms outside, James runs after Betty and Ned prepares for a zombie attack, looking for potential weapons).

Betty don't go outside come back!

(Voice Over Starts).

James: Betty wait up please.

Betty: No James I don't have time for your brother's stupid games I have a lot of things to do today… Look I'm sorry I'm just stressed out, you know Ned gets on my nerves, and he comes out with complete rubbish.

James: Betty you know I… Oh my god, look.

Betty: Oh my god it's Mr Wilson.

James: Betty don't go near him!

Betty: *(Growl sound comes from Mr Wilson then a sound of a bite).* Arrrrrrrgggggghhhhhhhhhhhhh!!! Get him off me!

James: Get off her you old bastard! *(Audience hears a punching sound).*

Betty: Oh my god he bit me!

James: Quick back in the house now!

(Voice Over Ends. James and Betty both run back to the house and lock the door behind them).

Ned: So how's the weather outside?

Betty: Shut up! Just shut up! I'm bleeding for fuck sake!

James: I'll go get the bandages.

(James leaves the room to go get a bandage then returns with it. Ned keeps an eye on Betty as he is thinking that she will become one of the undead).

Ned: That's not going to work.

James: Ring for an ambulance Ned.

(Ned pulls out him mobile and tries to ring for an ambulance; all he receives is a busy signal).

Ned: I'm not getting through.

(James goes over to the house phone and tries dialling on there).

James: Maybe if we keep trying we'll get through

Ned: Try the police or the army?

(James tries again).

James: Still nothing.

Betty: Oh god!

James: What is it?

Betty:	We need to warn Sarah and George about what's going on. They won't know what's happening, what if they come over here, and those things attack them?
Ned:	Fuck Sarah and George! We've got an apocalyptic situation in our hands.
	(Betty has a flare of anger in facial expressions towards Ned, almost like she wants to punch him hard).
Betty:	Maybe you're willing to let your friends get eaten, but I'm not!
James:	Maybe you should go lay down for a bit and I'll keep trying to call a doctor.
	(James guides Betty off, Exit Betty Digital clock re-appears showing an hour has gone by).

Scene Two

James:	You could be a little nicer to her.
Ned:	Why?
James:	Because she's my wife I love her and she means everything to me. I know things haven't been the same as they used to. I've grown up now, and I'm starting a family of my own now and I still want you in my life… but I can't do that if you don't get on with Betty. She has tried so hard to get on with you but you make it impossible to get along. Every time she tries with you, you just push her away…
Ned:	I'm sorry man, I didn't realise I was upsetting you the way I am with her. I know things are going to change when you get married and all that, but that's not why I do it. I just don't like her at all she talks to you and everyone else like she is 50 times her age; or like she's talking to class of 7 year olds. I can't help it but when I see her talking like that it just drives me up the wall.
James:	Can't you just get along with her for my sake; no one else's just for me. Just pretend you like her and get along with her, can you do that for me Ned?
Ned:	I guess so… I mean the state she's in I won't have to pretend for long.
James:	Ned!
Ned:	James, wake up for god sake, she's been bitten by zombie and even an idiot can work out that she is infected. I hate to spell this out to you,

	but as soon as the infection spreads she will die, then she will try and kill us.
James:	They must be something we can do... We have to leave the house, go find help.
Ned:	What?!
James:	We have to go find help, maybe if we find the army they will have a cure or something, and we can save Betty.
Ned:	Are you insane you saw them out there; the streets are roaming with the dead. Even if we get passed all the undead unbitten and unscratched how are we even going to find anyone alive. What are the chances that the army will help? They might be too busy fighting the dead to go back for someone who has already been bitten. What if there is no cure?
James:	It's a chance I'll have to take Ned she's my wife.
Ned:	Don't be daft James! At least before you make up your mind can we at least turn on the TV? They might be an automated message or information for help... I just don't want you rushing out outside into war zone. I've already lost my mate I don't want to lose my brother too.
James:	Ok...
	(Ned goes to put the TV on and starts changing the channel trying to find one that works or has any information on it).
Ned:	Here we go, we got something.
News1:	This is the Afternoon News I'm John Harris. There have been large reports around the country that the recently deceased are coming back to life and attacking the living. The Prime Minister has declared martial law in Great Britain until the crisis is resolved. Everyone is advised to stay indoors and board up your doors and windows. Also not to make any contact with the recently deceased. If anyone does encounter the deceased you must destroy the brain to stop the dead from getting back up any attacks to the body will do nothing. If anyone your with is bitten or scratch by the deceased, then you are advised to either quarantine the person or remove them from your premises. As far as experts have told us there is no current cue for the infected. Scientists are still looking for a way to fight the infection. That's all the information we have at this moment on the outbreak, we will continue doing our normal broadcasts to keep everyone updated, have a good and safe morning.

(Ned turns the TV off, James sits on the sofa looking devastated by the news of no cue, and a silence fills the room. Betty enters the room looking pale and weak).

Betty: James?

James: Betty what are you doing up? You should be resting in bed.

Betty: I couldn't sleep… did you get in touch with the doctor?

James: Well erm…

Ned: Yes! Yes we did.

Betty: What did they doctor say?

James: He just said to… just rest.

Ned: Yeah if you're not better by the afternoon to take you in.

Betty: James, are you ok? What's a matter?

James: Nothing… nothing really I'm just worried about you, I don't want anything to happen to you.

Betty: That's sweet don't worry hun I'm fine I just need to rest, just like the doctor said. Then we will see how I am after a nap.

James: Yeah, here why don't you try and have a kip on the sofa. You always found it easier having a kip in here on an afternoon.

Betty: Yeah I do.

(Betty goes to lays down on the sofa and James pulls out a blanket and makes her comfortable, Digital clock re-appears showing a few hours have gone by. Ned goes and looks outside the window).

Scene Three

Ned: Hey James?

James: Yes?

Ned: Who's that?

James: Mr Finch oh god has he lost his arm?

Ned: I wonder when his other arm will fall off.

James: Ned!

Ned:	Come on James were stuck in doors there's no TV channels working, the internets down, I have no weed left. I'm guessing you have no porn in this house either, and I am not going to play scrabble during the zombie apocalypse!... I'm sorry James I can't help it, I'm just trying to keep myself distracted, and everything is messed up.
James:	Don't worry two things I love about you, your sense of humour, and secondly the random crap that comes out of your mouth. I don't know what I would do without you.
Ned:	Be a boring shit?
James:	I love you too.
Ned:	Now who is that?
James:	Clarice… the street whore.
Ned:	Really? You never told me you had a whore on the street.
James:	Well I didn't want my neighbours to know my brothers a man whore and fucks anything that moves.
Ned:	Point.
James:	What are we going to do Ned? About everything that's going on out there. As well as hiding away in the house waiting for it all to blow over, and Betty's situation.
Ned:	You're asking me? You're the one with the brains in the family.
James:	Yes but you're the one who knows about this horror stuff and watches all the films. Not only that you're better at keeping your cool, and better than me in crazy situations. I know deep down what is the right thing to do… I just need you to say it, to be my voice of reason, to help me make the right decision.
Ned:	Ok… well let's look at all the facts, one were in a small house limited food and no guns. In this type of situation the best thing would be to wait for nightfall, and go find a better location with all the essential supplies to survive. Two the street is roaming with zombies, even if we get past them we don't know how many are at the end of the street. Finally three Betty has been bitten by one of them the question is what do you want to do about number three?
James:	Ok what are my options?
Ned:	First option would be to find a cure, but as seen as we know there isn't one yet that can't be an option, even if it was she's been infected for far

	too long. Option two we help her passing peacefully in her sleep then we somehow destroy her brain, so she can't come back... Something tells me that we're not going with that option. So the last option we wait till she dies from the infection then we destroy her brain.
James:	The last option then... it sounds like the best one to go with.
Ned:	Only question is who's going to... you know... destroy her brain?
James:	I'll do it.
Ned:	You sure? I mean I wouldn't mind bashing... *(Ned sees how upset James is by thinking about this).* Yeah, you do it.
Betty:	James?
James:	Betty you're awake, how you feeling?
Betty:	Still not better, I feel really drained and weak.
	(Seeing how weak Betty is James gets a little upset and Betty notices that something is not right).
James:	You just rest and I'll get the doctor over...
Betty:	The doctor isn't coming is he? James tell me the truth I know when you're upset you give that look on your face, the one you're giving now?
James:	No he's not coming.
Betty:	I'm dying aren't I?
James:	No don't be daft.
Betty:	Ned, am I dying?
Ned:	Yes you are.
James:	Ned!
Betty:	Hey, hey look at me, look at me its ok.
James:	No it's not ok it's just a stupid bite, just a stupid bite, you can't die... you're always so strong and brave about things and I'm not, sometimes I even wonder why you married me.
Betty:	I married you because you are the most remarkable person I have ever known, you're not like most men. You listen to me and do things for me without me even asking and you've never stopped showing me affection. I remember the night we first met you were checking me out

	all night was so cute. It wasn't till I came up to you on the dance floor and you said...
James:	Hi there do you want to dance?
Betty:	No you didn't you were mumbling.
James:	I was nervous.
Betty:	I liked it.
James:	Why does it feel like were saying goodbye?
Betty:	Because we are.
James:	I wish it wasn't like this we were just starting our lives together.
Betty:	At least I'm at home in your arms, you're the one person in my life I'd rather spend my last hours with.
Ned:	Betty I know I'm not the easiest of people to get along with, and we are just two different people. What I'm trying to say is that I'm sorry for been... The bitch has fallen asleep on me!
James:	Ned she's not breathing! No! Betty wake up, wake up!

(Ned goes to find an object within the room he can use as a weapon and goes over to James to pass him a weapon).

Ned what are you doing Ned?

Ned:	You know what has to be done now, you have to do this.
James:	No I can't do it!
Ned:	Ok let me do it then.
James:	No! No one's smashing her head in!
Ned:	Well if were not smashing her head in let's put her outside then.
James:	We're not putting her outside with those things! Out there.
Ned:	We can't leave her in here she's going to turn into one of them soon. We have to smash her brains in or get rid of her, I know it and you know it.
James:	I don't know what to do.
Ned:	Fuck it lets put her in the landing.
James:	What?!

Ned: Might as well till you figure out what we're going to do with her.

(James and Ned pick Betty up and carry her offstage, and then they both return to stage. Ned picks up a large object in the room and places it by the door, where they just put Betty).

There that should hold... James you need to keep it together don't lose it on me now, I need you to hang in there. I know you loved her very much, and I know for a fact she would not want you having a break down. She would want you to get up and start living.

James: How can I go on she meant everything to me, and she's gone just like that. I wanted to have a family with her, have a few kids, get a dog and decorate this place up. Now it's all gone everything I've ever wanted all fallen apart.

Ned: Look I'm about to say something really cheesy here, and if I have learned anything from all the movies I've watched and stuff. It is that someone is never really gone, they live on in our hearts and memories, and she will always been there as long as you remember her.

James: That's really cheesy.

Ned: You're ruining a perfectly good moment here.

James: Thank you... I will always remember her.

Ned: Me too, hey you remember that time when she asked me to go make her some coffee and I slipped in some laxatives *(James laughs)*. I don't think I ever seen her run so fast to the toilet.

James: That's not funny.

Ned: Why are you laughing then?

James: Ok I guess it was funny... that was her favourite dress she actually stayed up half the night cleaning it.

Ned: Good times.

James: I wonder what's happening out there; how far has the infection has gone? How many survivors' are out there? And what are those people doing to save the world? What do you think is happening out there?

Ned: Well there are loads of films and shows now about the dead were all aware of how to stop it. The world might have ended and we could be the last guys alive. That's not the case the world is ready to fight this I bet the troops are out there now taking care of the problem.

James:	If only Ned we haven't heard a single gunshot since this all started, in fact we haven't heard anything to say there is anyone out there.
Ned:	Yeah your rite… *(Ned gets a look of shock in his face)*. Oh crap!
James:	What? What is it?
Ned:	If there's no one containing the problem then it must mean they're going to nuke the city, it's what they do in the films
James:	What? They can't do that I mean they told us to stay indoors, I mean they would tell us rite if they were going to do that?
Ned:	When was the last time we checked the TV?

(James and Ned rush towards the TV and turn it on).

James:	Can't believe we haven't checked the TV till now.
Ned:	We really haven't had time to watch TV with all this going on.
News1:	I'm joined here by our news correspondent Jenny Dixon, what's the current situation out there Jenny?
News2:	Well John as reported earlier the military has put up barricades' around most major cities in hopes of containing the situations. Strikes teams have already gone inside to take out the recently deceased, but reports aren't looking good John. They are too many casualties and at the moment no one is entering the infected areas.
News1:	Does the government have any alternative plans to deal with the crisis?
News2:	There has been discussion into bombing the infected areas by the Royal Air Force, but nothing has been confirmed as of yet.
News1:	Even if this option is considered there are still survivors' hiding out within these cities isn't the government worried about possibly killing non-infected people?
News2:	At this time John everyone is considering, what is the best way to dispose of the infected? Without the infection spreading even further into the non-infected areas.
News1:	Thank you Jenny. Now into other news… *(James turns the TV off)*.
Ned:	I knew it, I bloody knew it, and they're going to nuke us… At least it's still under discussion we can make a run for it. All we need to do is make it to your car then we can run them down. If any of them come near us then we can just bash them on the head.

James:	I can't do this... look at me I'm not one for smashing peoples' heads in. I couldn't even do it to Betty; I've let her turn into one of those things out there, I just can't do this. You should go without me.
Ned:	What? Are you insane I'm not leaving you here with your zombie wife. You'll do something daft and get yourself bitten.
James:	If you stay you'll get blown up.
Ned:	You are not staying here I'm telling you that for sure James. You're going to move on, you're going to meet someone new, have lots of babies and die old, really old man warm in your bed.
James:	I don't know if I can do it.
Ned:	I know you can do it, you have it within you, are you with me?
James:	Yeah... what now?
Ned:	Now we need a plan... ok this is what we do; first we find anything we can use as a weapon for bashing heads in. Next we get into your car, run a few of them down for fun then get the hell out of this city before it blows.
James:	No we can't do that.
Ned:	Do what?
James:	To leave Betty here to get blown up.
Ned:	Bloody hell, ok new plan, get weapons, and then kill Betty, get in the car and drive the hell out of this dump before she blows.
James:	Ned, we can't do that to Betty.
Ned:	Ahhh for fuck sake... James I know she is your wife and you love her to bits. You must also understand she is a walking corpse bent on eating you. There is nothing left of the woman you loved, I'm sorry but she's dead... you need to decide here and now do we kill zombie Betty or not. We don't have all day to decide, they can drop the bomb any time they want, so you need to decide now... what's your decision?
James:	I'll do it now.
Ned:	Are you sure?
James:	yeah I'm sure; I have to do this, for her.
Ned:	Here then, you'll need this *(Passes James a bat)*.Before I open this door are you 100% sure you are ready to do this?

James: I am Ned, don't worry.

Ned: if I open this door and you let this bitch bite you I swear I will bloody bite you myself, understood?

James: Got it, just give me a minute.

Ned: I really don't mind if you let me do it.

James: No I got to do this... in a way I like to think there's a part of her still inside. Maybe not on the outside, but in the inside, trapped in her body watching through those monster's eyes... She would want me to be the last thing she sees, freeing her and putting her body to rest. Plus if she saw you, she knows you would be enjoying it.

Ned: No disrespect to Betty but I probably would, its end of the world and I haven't killed one zombie yet.

James: Well it's time we did, open the door... *(Ned pulls the barricade away from the door and James braces himself. Ned opens the door; a corpse slowly walks onstage in the form of Betty).*

Ned: Bloody hell she looks a mess.

Betty: *(Snarling and tries going for Ned).*

Ned: Do it now James!... quick!... James she's bloody after me!

Betty: *(Snarls).*

James: Betty... I'm so sorry I love you so much...

Betty: *(Snarls).*

Ned: Hit her now!

James: Arghhh!

(James swings the bat hitting Betty to the floor, with half her body behind the sofa. James then swings his bat constantly towards Bettys head).

Ned: You ok?

James: Yeah I'm good... she can rest in peace now.

(A moment of silence fills the room, then quiet snarling and growling sounds start and slowly gets louder).

Ned: Crap they must have heard you; we don't have long now we have to get out of here now before they break in.

(Zombies come into the theatre from different directions, scaring and creeping on the audience).

James: They've broken through the back door!

(Music slowly rises giving the zombies the cue to leave the audience alone and to chase Ned and James off-stage, Lights Fade).

Scene Four

(Digital Clock comes on showing the time 10:00pm, Lights Fade up revealing a wrecked house Chris is looking out of a window waiting for a zombie to appear. Sarah and George enter the room and Sarah is looking frustrated at George.)

Sarah: Will you stop following me everywhere I go in this house!

George: I'm just making sure your safe.

Sarah: I was just going to the toilet George nothing is going to get me in there.

George: You never know, what if a zombie flies through the window while you're washing your hands, or what if you're on the toilet and a zombie comes through the bottom of the toilet and gets you.

Sarah: George stop been stupid! The toilet is on the second floor and no zombie can fit through the toilet pipes, your just overreacting.

George: I'm just being cautious Sarah these are dangerous times we live in now. Zombies' are like ninjas in the dark silent but deadly, and all it takes is one bite or scratch and you're dead.

Sarah: It's not that dangerous that you have to hold my hand everywhere I go, I need my space or I am going to go insane in here.

George: It's not safe to wonder alone you never know when a zombie will come round the corner and get you.

Sarah: Even so we've already checked the house there is no one here but us, and zombies' just don't magically appear.

George: I know Sarah but…

Sarah: But nothing George! That's the end of it!

(Sarah goes to leave the room and before she does George speaks up.)

George: Sarah… where are you going?

Sarah: I'm off to the bloody kitchen George!

George: *(Starts to walk towards Sarah.)* Maybe I should…

Sarah: Stay here George!

(Silence fills the room as Sarah walks off-stage leaving George left stood still looking like a lost puppy, not knowing what to do next. George sneakily makes his way towards Sarah's exit, leaving Chris looking confused by his actions. As George gets near the exit, Sarah shouts.)

I mean it George, stay in there!

(George stops in his tracks and turns around in shame.)

Chris: You my friend have a serious case of paranoia.

George: No I do not I'm just scared something will happen to her.

Chris: Paranoid.

George: No I am not! Its fear ok, just fear.

Chris: You know nothing about fear.

George: Oh and you do?

Chris: It was a cold, wet foggy morning *(Lights slowly fade to a light blue and the sound of wind blowing fill the stage, Chris looks centre stage almost in a trance.)* I was down by the cobble wall on Paddy's farm and there was a strong smell of bacon in the air, mostly because I had a bacon sandwich. Before I could get a bite I looked into the fog and noticed a figure walking our way. I said to Paddy who do you think that is over there? Paddy said maybe its old Phil you know talkative old guy never catches any fish.

So Paddy goes up to the figure to whomever it was, then Paddy froze for some reason, the figure was coming towards him, Paddy turned round quickly and tripped over, then I saw the figure attack him. In that moment I knew I had to do something, so I put down my bacon sandwich and rolled up my sleeves and started a steady run towards them, and before I got any further down the field, I saw more figures approaching from the mist, they were going straight for paddy.

I took a moment to look at my surrounds and count how many they were while paddy was been attacked. There must have been twelve of them attacking paddy, all I could do and say was… Fuck this! And I ran in the opposite direction and over the wall. After I leaped over the wall I knew I had to go back, there was no way I was going to let this go, I

	just couldn't run away from the situation so, I ran back to the cobble wall... and grabbed my bacon sandwich.
George:	What the hell? You left your friend behind then came back for a stupid sandwich.
Chris:	Hey! Don't you judge me, you wasn't there, there was too many of them what could I have done? I was just too scared. When you get up close to them and see what they really are. There was the horror of that plus I didn't know when I next come across a bacon sandwich. If it is indeed the end of the world, you have to take advantage of any luxuries you have left.
George:	I've seen zombies' up close too, so I also know this fear.
Chris:	No you don't you wimp, you run at the first sight of blood. I've seen the way you are with Sarah. At the first sight of trouble or creak of a floor board you're ready to run. I bet you would even push Sarah down just to give yourself a fighting chance, I can see it in your eyes.
George:	How dare you! I would never do that, you know nothing about me, so how can you even stand there and judge me?
Chris:	We'll soon see when the dead come knocking, then we will know if you're a man or a bacon sandwich for a zombie.
	(Silence fills the room as George and Chris glare at one another waiting for the other person to make the first move. Sarah enters the room with some snacks she has found. Chris backs up to his window to continue his watch, and George looks relieved this confrontation has ended.)
Sarah:	What's wrong with you now?
George:	Nothing I'm fine.
Sarah:	Are you sure? You don't look fine.
George:	Yeah I'm fine, don't worry I'm ok.
Sarah:	Ok, so what are we going to do now?
George:	What do you mean?
Sarah:	Well what's the next plan, we got here safe and luckily found Chris and even secured this house to stay in for the night. You do know we can't stay here forever, there are not enough supplies and there are too many windows in this house. We cannot live here in the long run, and there are too many zombies' in the area, I just don't feel safe here.

George:	Were fine here for now, we have a decent amount of supplies which will last us a few days. We also safe here, the zombies' don't know we're in here.
Sarah:	But for how long for George?
George:	I don't know.
Sarah:	Hours, minutes?
Chris:	Seconds.
George:	Look we're safe for now we might not get another chance like this.
Chris:	Until they find us.
George:	Stop it Chris! Stop been negative, look we're safe here and outside there is zombie people, dogs', cats', pigeons'. I don't know about any of you, but I am not going back out there it's too dark, and we can't see them, especially the small ones.
Sarah:	George stop being stupid, look if you feel this way then we will stay for the night, but we can't stay here forever we have to move on in the morning it's just not safe and secure to hold up here in the long run.

(Chris looks out of the window and focus's hard to look outside, he sees a lot a movement, but all the street lights have gone off he cannot see a thing but he knows deep down that the living dead are on the move.)

Chris:	You spoke too soon.
George:	Why spoke too soon what's happening out there?
Sarah:	Sssssshhhhh George it will be nothing.
George:	What do you mean nothing, why would he say that after about talking about this house not been safe to stay in?
Sarah:	I don't know George but will stop talking for one second while we find out what's happening. You overreacting will attract them here if you don't shut up!

(Sarah goes over to the window alongside Chris trying to figure out what is happening.)

George:	What can you see out there?
Sarah:	Ssssshhhhh!
Chris:	it's too dark out there it's hard to tell what's happening out there, I sure I saw someone running.

Sarah: What do you think is happening?

Chris: Maybe someone is out there and they've been spotted and now their running for survival. Either that or those demons have cornered some poor animal.

Sarah: Aww I hope it's not a dog.

Chris: I hope not zombie dogs' are very deadly and fast.

(Sarah sees a shadow.)

Sarah: What was that?

Chris: Something is coming over here.

George: Oh god they've found us, we have to leave now!

Sarah: George shut the hell up!

Chris: Something's trying to get in.

George: Oh my god this is it were going to die!

(Sarah goes over to George and slaps him in the face.)

Sarah: You're going to get us killed!

Chris: It's too late for anything we need to hide now they're coming inside quick.

(Chris, Sarah and George leave the room to hide in the house, while two familiar enter the stage.)

Scene Five

(James enters the stage first then Ned follows after.)

James: This place looks abandoned Ned.

Ned: I'm telling you I heard something from in here.

James: Well what did you hear? For all you know it could be a zombie.

Ned: No it wasn't I know the sound of the dead, this sound was human it was really faint, almost sounded like someone was whining like a little bitch.

James: Well I can't hear anything in here its quiet, maybe you heard things we should just go we don't have time to stop and look around.

Ned: We might as well stay here for the night and get some rest we almost got killed back there.

James: You mean you nearly got us killed by dropping your mobile, why did you even bring it for. It's not like there's any signal or anyone who would want to txt you. Especially during the zombie apocalypse, where everyone we know are either dead or running for their lives.

Ned: You never know there's always time for a cheeky text message, and we might get some signal and someone might text or call, we just don't know who's made it. Who knows anyways James, there's no need for you to get your knickers in a twist about it.

James: Ok fair enough, now go check upstairs we need to make sure it's all clear if were staying the night.

Ned: Why do I have to check if it's clear up there?

James: Because you have the bat.

Ned: You can have it back if you want?

James: Ned!

Ned: Fine I'll go check up stairs, but if I get infected I'm coming for you first.

(Ned goes over to the door to check up stairs, he opens the door to find Chris, Sarah and George stood there in fear. At first sight of Ned all three of them scream/shout. Then Ned shuts the door on then bringing silence back to the room. James goes over to the door that Ned shut and opens it again, now seeing relief on Sarah and Georges face.)

Sarah: James! *(Sarah jumps into the room to hug James.)* I'm so glad to see you're ok.

George: Glad you made it in all this chaos, where is Betty?

(James looks down and saddened when asked about Betty.)

Sarah: James where is Betty?

Ned: We bashed her brains in.

George: What!?

Ned: Don't worry, she wasn't alive sort of, well she was dead first, then she came back from the dead, then we bashed her brains in.

Sarah:	Oh James I'm so sorry *(Hugs James tightly.)* By the way this is Chris, we found him when things got crazy and we've been hiding here since. Chris this is James and…
James:	My brother Ned.
Ned:	Yo man.
Chris:	Nice to meet you both.

(George cautiously walks towards the door listening.)

George:	Sssssshhhhh do you hear that?

(Everyone goes quiet.)

James:	Hear what?
George:	I heard something in the landing… did you lock the door when you came in?
James:	I don't know I was the first one in to check this place out.

(Slowly everyone turns their heads towards Ned.)

Ned:	What?
James:	Ned did you lock the door behind us when we came in?
Ned:	No…
James:	Ned!
Ned:	How could I? We broke into here, we broke the lock just getting in here, and how can I lock it.
George:	Barricade it!
Ned:	What I'm not daft, I'm not going to barricade a house we haven't fully checked out, for all I know this house could have been full of zombies'. I left it as an easy exit just in case.
George:	You Moron! You've doomed us all
Sarah:	George, keep it down your too loud.
Ned:	No need for that language man.
George:	You're a moron there I said it again.
Ned:	How about we take this outside?

George: What with zombies' out there you're mad.

Ned: No I just have balls of steal

Sarah: Can you two stop it.

Chris: I think something is in the house.

(George rushes towards the front door in hopes of locking it before it's too late. George opens the door to the landing, as the door opens a zombie comes out fast and dives on George. The zombie's bites George's arm, Ned and James rush to the rescue. James pulls the zombie off George and pushes the zombie to the side. Ned then come in with the bat and attacks the head of the zombie till it stops moving. Both James and Ned pick up the zombie and take it back outside, and then they secure the door and return on stage. George pulls up his cardigan sleeve to find that the zombie has broken into his skin.)

George: Oh my god it broke into my skin, I'm going to die my life is over!

Sarah: Calm down George I'm sure you're going to be fine, it doesn't look that bad.

Ned: Nope he's a goner alright.

James: Ned!

Ned: What he's been bitten, the zombie broke skin which means he's infected.

Sarah: There must be something we can do to save him like an antidote of some kind of medical treatment?

(James and Ned exchange a look at one another, and then James gives Sarah some bad news.)

James: I'm sorry Sarah there isn't anything we can do to help George, believe me I know what you're going through I was the same with Betty. There isn't even a cure yet... George I'm sorry there's nothing we can do to help you, I wish there was but there isn't.

George: I can't believe this is happening to me, I had big plans, so much I wanted to do... how long do I have left?

Ned: Well Betty had a bigger bite she lasted like four to five hours. A small bite like that, I don't know I'd say you might have a few more hours than Betty. That's just a guess I've only ever seen one person get infected and turn.

Sarah: Oh George *(goes to hug him.)*

George: No Sarah don't come near me, I can't risk you catching this.

Sarah: But George.

George: Please just keep away from me, I don't know what I'd do if you was infected too.

Sarah: I love you George.

George: I love you too Sarah.

Chris: Maybe it's time we took some extreme measures to keep our selves safe especially with George turning.

James: What do you mean extreme measures?

(Chris pulls out a gun.)

Ned: Sweet man!

George: What! You had a gun this whole time! Why didn't you say? It could have prevented me from been bitten.

Chris: I didn't want to make a loud noise, that's why it's an extreme measure.

George: What to shoot me?

Chris: Well yeah or a last resort for myself if I got surrounded by them

George: What?!

Ned: He's right there.

George: Of course you would agree with him you delinquent.

Ned: If he used a gun in here all the zombies on the street would have heard the gun shot. Then we would have had an entire zombie horde on the door step, and then we would be seriously fucked.

James: Where did you even get a gun from?

Chris: It was a cold, wet foggy morning *(Lights slowly fade to a light blue and the sound of wind blowing fill the stage, Chris looks centre stage almost in a trance.)* I was eight years old, my father came up to me and gave me then gun and said, today I become a man, and if any hippies came over the wall I were to shoot them.

You see there was these protests going on outside our farm to stop a construction company from knocking some trees down. The previous

night some of those hippies came over wall and stole some eggs from our hen house. So my father armed me, I never did fire this gun, they never did come back to our farm especially after that night when we found two of them in the barn. Apparently they were wrestling naked, so my father told me. I never did see what happened next, my father told me to leave, but I heard lots of screaming and gun shots.

So I keep it on me every day, in case the time comes when I have to arm myself, or to pass it down to my own son so he may protect himself someday.

Sarah: Aww you have a son?

Chris: No not yet, but you never know when that time will come.

James: Okaaaaaaay at least we now have a gun.

Chris: Does anyone know how to use a gun?

George: What!?

James: It's your gun, are you telling me you have never fired it before, not even to practice with or mess about with?

Chris: I've never had a reason to use it, and playing with guns is dangerous.

Ned: I'll use it.

Chris: Ok. *(Chris goes to give Ned the gun when George butts in.)*

George: Wow wait what are you doing giving a gun to him for, he's a delinquent we can't trust him with a gun. He probably doesn't know how to use it, unless he has experience committing crimes. Do you have any experience with using fire arms?

Ned: Of course I do.

All: You do?

George: What experience do you have?

Ned: I'm Prestige level eight online.

Chris: Good enough for me. *(Chris passes the gun onto Ned.)*

George: What!? You're giving a gun to someone who has only experience shooting is on a computer game?

Chris: Yes...

George: Oh my god, were all doomed to die in this house.

Ned: We will be if we have to listen to your whining all night, it's no wonder one of them came up here to bite you.

George gives Ned an evil glance after that comment, George looked almost he was going to explode at Ned.)

James: Look everyone calm down no one's shooting anything at the moment it will attract the dead, and that's the last thing we need right now.

Ned: He's right, one clip isn't enough to take them all, and it can only be used as a last resort in any case.

Sarah: What do we do now it's not safe here we don't even have a front door?

James: Leave.

Ned: We can't it's not safe out there.

George: And it is here?

James: What about the bomb?

George: What bomb!?

James: There was a news report saying the military are thinking about bombing infecting areas for containment, which is why we should keep moving.

Sarah: I can't believe this.

Ned: Look it's not safe running about out there in the dark. We have the choice of street full of zombies or blown up by a nuke, either way the options aren't good. Look we need to rest for now and at first light we'll make a move.

James: They can drop the bomb any time, you said that yourself.

Ned: I know I did but we weren't getting far outside, it's a risk we have to take, it's not a good one but we have to be safe. So for now I think now we should just get some rest and we'll move at first light.

James: Ok then.

Chris: I'll second that and I'll take first watch then.

George: I'll just slowly die over here.

Ned: Drama queen.

James: Ned!

Sarah:	George.
George:	No Sarah I'm dying here I don't have time to sit around listening to delinquents' I'm dying slowly here and now there's talk of a bomb, the situation is just getting worse.
James:	It's too dark to be running around out there Ned's right, and we did nearly did get killed out there, because we can't see where we are going. I'm sorry there's nothing that can be done about your situation I wish there was hope for you, but there just isn't. Look we'll rest until its gets light and hopefully we can sort something out and make a plan to get out of here, and just maybe someone found a way to stop the infection from killing you.

(George sits down feeling helpless, Chris starts his watch while the others find somewhere in the room to rest. Lights fade down.)

Scene Six

(Digital clock appears showing the time 3:30am, Lights fade up. James is now taking watch looking through the window. George is looking tired and miserable Sarah wakes up and sees him. Sarah makes her way over to George to comfort him.)

Sarah:	Hey how you feeling?
George:	I feel really tired.
Sarah:	Haven't you slept at all?
George:	No I haven't.
Sarah:	You should get some rest then you're going to need all your strength.
George:	I'm too scared to go to sleep I'm worried if I slept I'll never wake up again. What if I woke up as one of those monsters and start attacking you, I just cannot bare it.
Sarah:	Oh George stop been silly, look we will find a way through this.
George:	It's already past the time it took for Betty to turn from the infection, and I could die at any minute.
James:	Maybe it's time we got everyone up and decide where we're going next, it's starting to get light now so it should be easier to find somewhere safer to hold up at.

(James nudges Ned and Chris to wake them up.)

	Ok we need to decide where we're going from here?
George:	Somewhere with lots of supplies like a shopping centre.
Ned:	Bad idea, when end of the world comes along everyone goes to a shopping centre which means it could be full of zombies. Only an idiot would go to a shopping centre during the zombie apocalypse.
James:	What about another house?
Ned:	Nah we'll just end up in the same situation we've been in every house we go to.
Sarah:	What about the hospital maybe we can find any survivors or anyone who has an idea how to help George.
Ned:	Worse idea ever, hospitals' are full of dead people it's like walking into a graveyard its suicide. Look guys we can't be stopping at houses', shops' or hospitals' remember a bomb might drop any time.
Chris:	What about a farm?
George:	That's silly idea.
Ned:	A farm is not a bad idea.
George:	What are you serious? You disagree with us but agree with him?
Ned:	Yeah farms are out there in the country side where there's less or not many people, so less chance of bumping into zombies. Also it will be far enough from the city centre so any nuclear attacks come we might be far enough if we're lucky.
Sarah:	It's too far away to get to in the first place.
Ned:	That's the point of going to a place where there it is far out and barley anyone, and we can grow our own food to live off.
Sarah:	We won't even get that far, if what you say is true about a bomb we don't have much time.
Chris:	Sounds like a good idea to me.
James:	Like Sarah said it's far away, how we even going to get all the way to a farm before we run out of time??
Ned:	Hotwire a car.
James:	What? You can hotwire a car?
Ned:	Yeah.

James:	How did you learn to do that?
Ned:	Work experience Jimbo's Garage.
James:	Didn't he get arrested for stealing cars?
Ned:	Maybe…

(George slowly makes his way to the exit door, no one notices him.)

James:	Ok so it's agreed we get a car and make our way to the country side?
Chris:	Agreed.
Ned:	Oh right let's do this then, but I'm driving.
James:	Why you?
Ned:	I've never driven a car before I might not get another chance, plus I'm not afraid to run a few of them down if need be.
James:	Ok then Ned.

(George opens the door and Sarah spots him.)

Sarah:	George what are you doing?
George:	I'm leaving Sarah.
Sarah:	What do you mean leaving?
George:	I can't go with you, I'm infected it's not safe to be around me, I'll just get you killed.
Ned:	He's right he's a goner you should let him go.
James:	Ned!
Ned:	What? He can't come with us, look at him he's going drop dead any minute. Plus if there's any military check points on the way there not going to let him through. I don't want to be in a small enclosed small with someone who's turning into a zombie.
Sarah:	We can sort this out George, please don't leave me I love you.
George:	I love you too Sarah, but I cannot go with you there's no hope for me now I'm dying. I cannot risk been around you with me been infected, I don't want to hurt you. James will you do me a favour and look after Sarah for me please?
James:	I will do George.

Sarah:	What? No we are not talking about this!
George:	I'm sorry Sarah this is the way it has to be, the only way I can protect you, and give you a fighting chance… good bye my love. *(George runs off stage.)*
Sarah:	No George! *(Sarah runs after George.)*
James:	Sarah no!
	(After Sarah and George exit the house they left the door open for zombies to come in. Ned, James and Chris can hear the sounds of the dead once again, and they know they have broken in. Chris charges towards to the landing door to hold it, he can hear the dead just outside. James begins pacing up and down thinking what to do next.)
Chris:	There on the other side it won't be long before they get in.
	(Ned starts laughing.)
James:	Why are you laughing Ned what's so funny?
Ned:	*(Still laughing.)* George would be so pissed off right about now.
James:	Why would he be?
Ned:	Because you said you would look after Sarah, and she ran outside to get eaten with him. *(Ned continues to laugh.)*
James:	Ned! There's no time for this!
Ned:	Okay but you got to admit it's funny.
Chris:	Guys' the zombies' are at the door we need a plan.
James:	What are we going to do Ned?
Ned:	Get the hell out of here that's what.
Chis:	We can get out through the window in the next room.
Ned:	No bad idea the zombies outside would see us and we would be cornered in the garden.
James:	We'll just jump into the next garden then.
Ned:	We can't if they saw us climbing over then that garden would be surrounded too, and since we haven't check next door out, we don't know if there's any zombies inside.
James:	Is there anything we can do then?

Ned:	We'll take the back door if it's all clear, these streets have a back alley way don't they?
James:	I think so.
Chris:	It does, and it was clear when we checked it out, that was when we first came to the house. The back gardens connect into an alley way which leads down the road to another street.
Ned:	Brilliant we'll take the alley way, find a car in the next street and get the hell out of here.
Chris:	I don't know how long I can hold this door for.
James:	We have to do this now.
Ned:	We can't yet.
James:	What? Why not?
Ned:	Even if we run now, they would break through and chase us. I won't have enough time to hotwire a car. Chris you need to hold the door as long as you can then run for it. James you wait at the top of the Alley so Chris knows which way to run, and I'll hotwire a car.
Chris:	Quick get out of here before they break through, I'll be right behind you.
James:	Ok Ned lets go.
	(James and Ned exit the stage using the audience's exits. While Chris holds the door, after a minute of James and Ned exiting the stage Chris braces himself to leave.)
Chris:	Ok that should be enough time for them to get a car ready, it's now time for me to run for my life, here goes.
	(Chris runs for his life from the door to the audience exit that James and Ned used. As Chris left the door on stage zombies burst through charging after Chris and exit. An Air Raid Siren plays in the backgrounds until the sound of a bomb goes off. Music slowly rises for the end of the show and Lights Fade.)

The End.

www.ingramcontent.com/pod-product-compliance
Lightning Source LLC
Chambersburg PA
CBHW072307170526
45158CB00003BA/1221